DC Zoo Train 2m !!

To ♡ **W9-BUB-703**

love, Erin & Bob

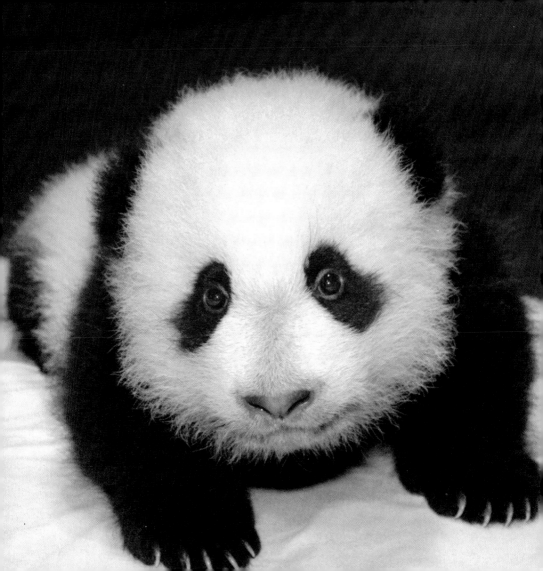

PANDA CAM

A Nation Watches Tai Shan
the Panda Cub Grow

Friends of the National Zoo

FONZ
Friends of the National
ZOO

A FIRESIDE BOOK
Published by Simon & Schuster
New York London Toronto Sydney

FIRESIDE
Rockefeller Center
1230 Avenue of the Americas
New York, NY 10020

FIRESIDE and colophon are registered trademarks
of Simon & Schuster, Inc.

Designed by Joy O'Meara

Manufactured in the United States of America

1 3 5 7 9 10 8 6 4 2

Library of Congress Cataloging-in-Publication Data is available.

ISBN-13: 978-0-7432-9988-6
ISBN-10: 0-7432-9988-4

For information about special discounts for bulk purchases,
please contact Simon & Schuster Special Sales:
1-800-456-6798 or business@simonandschuster.com.

Introduction

July 9, 2005, was among the most important dates in the 117-year history of the Smithsonian's National Zoological Park. When the Zoo announced that a giant panda cub was born at 3:41 A.M. at the Zoo's Fujifilm Giant Panda Habitat, it seemed the whole world took notice. Panda fans everywhere were able to watch and listen to every cuddle, lick, and squeal of a tiny panda cub and its doting mother on the Zoo's website, via "panda cams" trained on the secluded den. And people did so in astonishing numbers! Many reported maintaining near 24/7 vigils on their computers so as not to miss a minute of the action, even when the action was merely mother and baby sleeping.

Until the cub's birth, National Zoo staff were still not entirely certain that mother Mei Xiang was pregnant. Mei Xiang and male Tian Tian had failed to mate during Mei Xiang's brief spring estrus, so National Zoo scientists stepped in to help. Using techniques they had been perfecting for years, the scientists artificially inseminated Mei

Xiang with Tian Tian's sperm on March 11. Then, with no surefire way to tell whether a panda is pregnant or to predict the length of gestation (which may vary from three to six months), staff, along with the pandas' adoring public, started the long, anxious wait.

While they waited, responses to every possible birth scenario were mapped out. What would they do if Mei Xiang rejected the cub? First-timers often may be less than perfect mothers. What if she had twins, or if the cub appeared to be in distress? Fortunately, none of these things happened. From the first, it was clear that Mei Xiang was a great mom and the cub looked robust and healthy. Still, Zoo staff and volunteers from Friends of the National Zoo (FONZ), the Zoo's nonprofit support organization, watched mother and cub around the clock, via cams as did everyone else, for the slightest sign of anything going wrong. But with every passing day, confidence grew that, finally, the National Zoo had a panda cub to call its own.

The Zoo's quest for a panda baby began in 1972, when Ling-Ling and Hsing-Hsing arrived from China as a gift to the American people following President Nixon's historic visit to China. But year after year, hopes were dashed. For a decade, the pair did not mate during the annual breeding season. When they finally got it together, between 1983 and 1989, the pregnancies resulted in five cubs, but each sur-

vived only a few days. Female Ling-Ling died in 1992 and Hsing-Hsing seven years later, leaving no progeny.

Mei Xiang and Tian Tian arrived from China at the end of 2000. Staff didn't expect these youngsters to mate the following spring, and they did not. The next year, the pair mated very briefly, but no pregnancy ensued in 2003. In 2004, Mei Xiang and Tian Tian tried, but did not mate, and an artificial insemination failed to produce a pregnancy. Finally, in 2005, the stars aligned—and a star was born.

In the early days, Zoo staff left Mei Xiang and her cub completely alone, wanting above all not to disturb Mei Xiang in any way while she and her baby, born blind, helpless, and nearly naked, bonded. It wasn't until August 2, when the cub was twenty-seven days old, that Mei Xiang left the cub's side long enough for keepers and veterinarians to do a quick health examination. They learned, among other things, that the cub was a male and he weighed just under two pounds, up from an estimated four to six ounces (the size of a stick of butter) at birth.

Over the next weeks and months, keepers, cam watchers, and volunteers who operated the Web cams closely tracked the cub's accomplishments and adventures: He opened his eyes on day 47. He took his first wobbly step on day 76, and his first teeth erupted on

day 88. He followed his mom outdoors at five and a half months. Finally, by seven months, he was spending most of his days perched high in a tree, taking in the sights and sounds of the great outdoors between long naps. At about the same time, he met his father, Tian Tian, if only through a mesh window: panda fathers play no role in parental care, and it is unlikely father and son will ever share a single space.

All the while, the media breathlessly reported every milestone; every picture the Zoo released appeared on front pages around the world, and the cub's faithful fans continued to watch his every move on the panda cams. Blogs sprang up so fans could share their thoughts and observations on the cub and his mom and exchange screen shots from the cams. A naming contest conducted by FONZ gave members of the public the chance to vote on their favorite of five choices. More than two hundred thousand people from as far away as China, Poland, Brazil, and New Zealand cast their ballots to select the cub's name. (Bloggers started their own campaign to name him "Butterstick" and even proposed a national holiday on his birthday to be called "Stickmas.") On October 17, when he was one hundred days old, following a Chinese tradition, the cub was formally named Tai Shan, meaning "peaceful mountain." The media turned out

in full force for the naming ceremony; one nationally televised morning show even went live for the announcement by Zoo director John Berry and remarks from the People's Republic of China's ambassador to the United States and other dignitaries.

But Tai Shan was still being kept largely under wraps. Zoo staff wanted to be sure that Tai Shan and Mei Xiang would be entirely comfortable with throngs of real visitors. To get Tai Shan and Mei Xiang ready, and so staff could assess their reactions, a handful of special guests and FONZ members were permitted to go indoors at the Fujifilm Giant Panda Habitat to catch a glimpse of the increasingly rambunctious cub.

At long last, on November 18, the Zoo announced Tai Shan's public debut would be on December 8, and that free tickets for timed entry would become available on its website. The news flashed around the world, and the full complement of thirteen thousand tickets for viewing between December 8 and January 2 was reserved within two hours. And almost immediately, a few ticket holders were offering their tickets on craigslist and eBay, only to be roundly condemned for their greed by a host of the disappointed ticketless.

Tai Shan's debut was marked by an even greater media frenzy than his naming ceremony. The first picture of Tai Shan in the snow,

in late February, made the front page of *The Washington Post,* and *The New York Times* used him as a jumping-off place for an article on the science of cuteness. The Zoo continues to receive many e-mails every day, as it has from the first, from people around the world still devotedly watching the panda cams and wanting to convey the joy Tai Shan brings them. The panda cams on the website have logged more than fifteen million visits from people in more than one hundred countries. By the time Tai Shan was eight months old, thousands of people had visited the Zoo to see him in person, all before the usual spring peak in Zoo visitation. Among his many notable visitors were First Lady Laura Bush and actress Nicole Kidman. We hesitate to predict how many millions more will visit before Tai Shan's return to China sometime after his second birthday. Part of our agreement with the Chinese government is that any pandas born in the United States will go back to China to participate in the breeding program there and one day be parents themselves.

Giant pandas are endangered in their native China, where only about sixteen hundred individuals survive in the wild. There are just under two hundred in zoos worldwide. So every zoo-born giant panda represents a significant step toward saving this beloved species. Equally important is the role Tai Shan, Mei Xiang, and Tian

Tian play as conservation ambassadors, helping to inspire concern for all endangered species and their habitats. Scientists at the National Zoo are leaders in studying and conserving giant pandas in zoos and in the wild. But without public support, their scientific efforts might be in vain.

For this reason, Friends of the National Zoo is pleased to publish this book of images and excerpts from the regular diary entries posted on the panda pages of the Zoo's website during Tai Shan's first seven months. We hope people enjoy it as a chronicle of the development of this panda cub superstar, and as a reminder of what we stand to lose should this magnificent species go extinct.

—Susan Lumpkin
Friends of the National Zoo

PANDA CAM

Mei Xiang gave birth to a cub at 3:41 A.M. on July 9. Mother and cub seem to be doing fine.

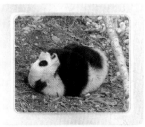

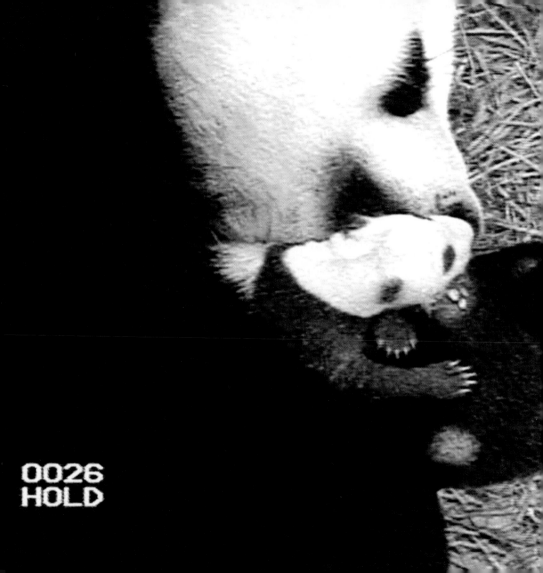

0026
HOLD

The cub is active and loudly vocal, and Mei is showing signs of being a great mother. She picked up the cub within about two minutes of its birth and has been cuddling and cradling it since then.

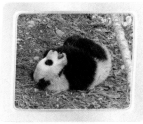

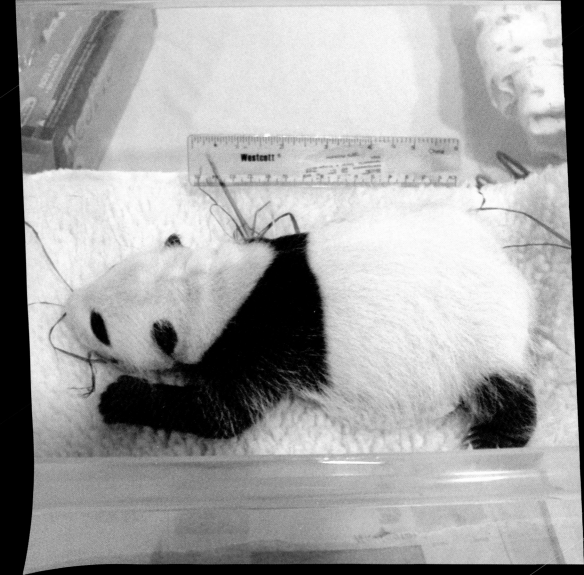

At the cub's first health exam, we learned that it's a boy! He looks healthy, weighs 1.82 pounds, and has a total body length of twelve inches. The cub was very quiet during the nine-minute exam, and let out only one squawk when his mouth was examined. He is very solid and sturdy and extremely cute.

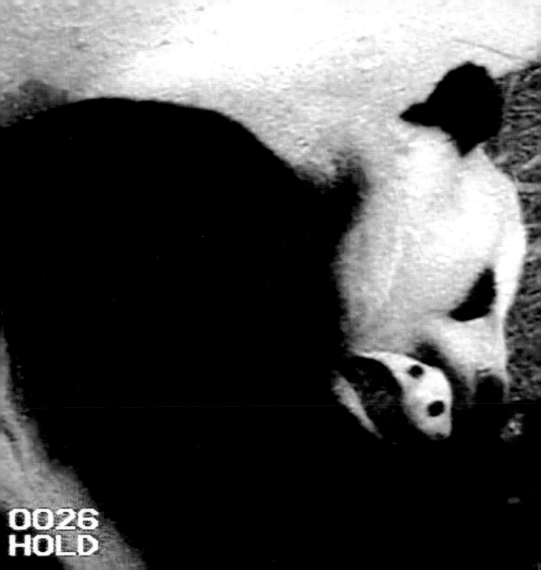

0026
HOLD

The cub continues to grow. Except for a few grunts, the cub may be quiet for an hour or two, and then he will complain if Mei Xiang shifts positions or when, we believe, he is ready to nurse. Imagine Mei Xiang's relief when she finally settles into a position that is comfortable for the cub. On a few occasions, the cub's vocalizations sound like sharp little demanding barks!

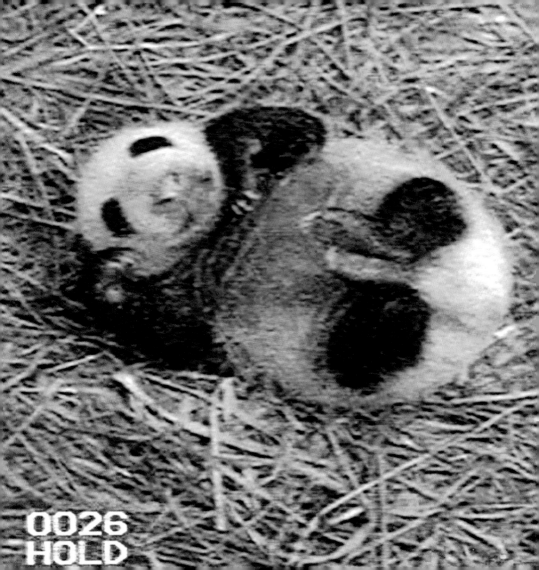

0026
HOLD

This morning Mei left the cub to get a drink of water and eat some bamboo in the nearby indoor exhibit. We went to retrieve the cub for his exam and were wobbly-kneed with excitement.

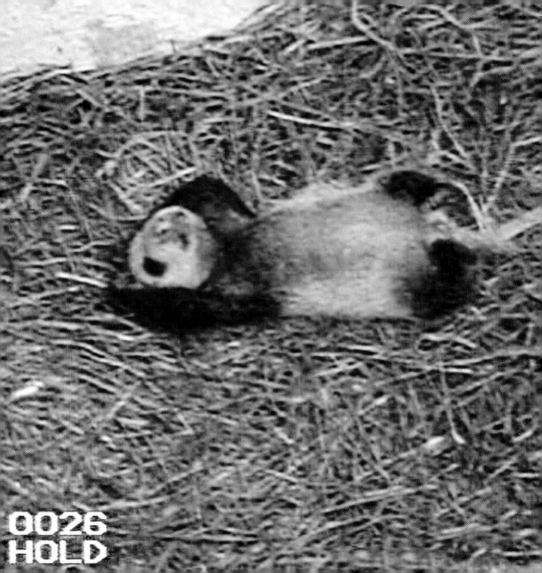

In the past month we've seen the cub grow from a nearly hairless newborn to a tiny panda, taking on the distinctive black and white markings. He is still helpless but has started to lift and bob his head and right himself from a side position.

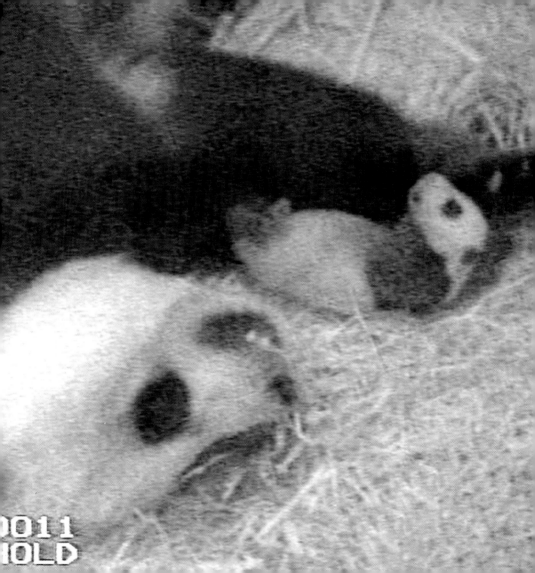

Our giant panda cub is five weeks old and thriving under Mei Xiang's attentive care. The cub's next milestone is opening his eyes, which could begin anytime now. Everyone wants to be the first to detect that he has opened his eyes.

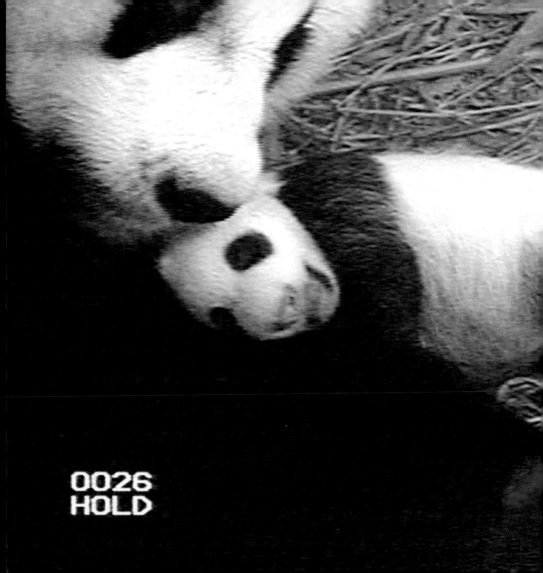

The cub is now large enough to be Mei's personal pillow upon which to rest her chin, an arm, or even her head. We are often treated to a view of the cub's rear and tail as he attempts to squirm out from underneath Mei's weight. Mei and her watchers still jump when he squeals to communicate his discomfort.

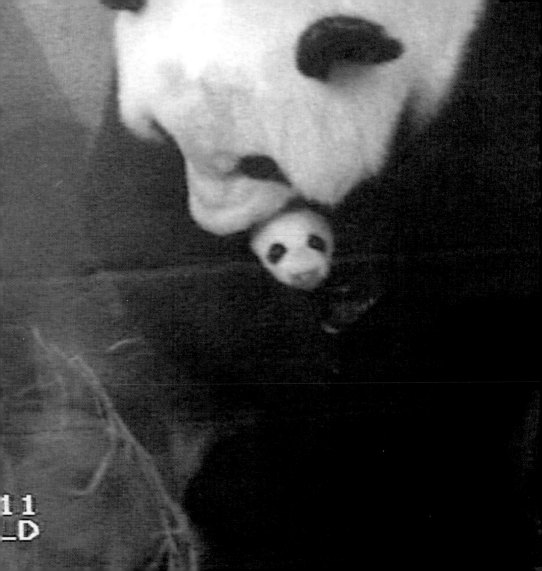

We think that if you watch the panda cam closely and often, you can actually see the cub growing. We see a consistent phenomenon: even the least excitable people are turned into "oohing" and "ahhing" panda fans, who leave the observation room giddy and smiling.

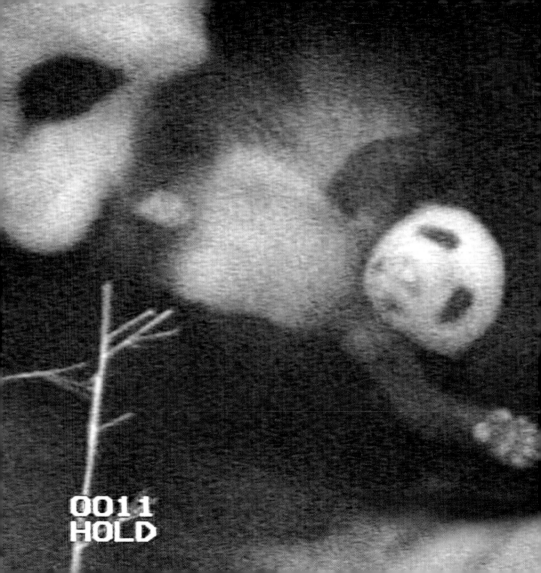

The other day the cub reacted for the first time to the sound of the door being operated. This may indicate that the ears are fully open and functioning now. The cub acted startled and then was very active, grunting off and on for about half an hour.

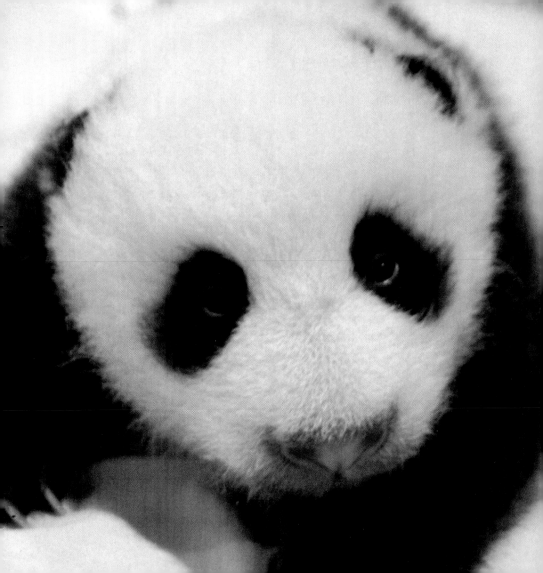

The cub's eyes were first noted to be open yesterday afternoon. There has been no apparent change in his behavior since then. However, now that his eyes are open, we think he looks even cuter, smarter, and more engaging than any other panda cub, ever!

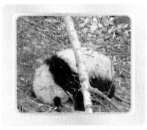

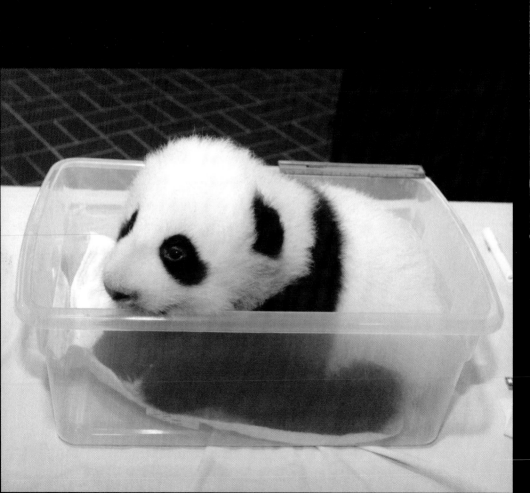

We are just in awe of our little bear. He has been vocalizing more. He barked several times during his exam. It seems like such a long time ago—not just ten weeks—that he was a tiny squealing pink newborn. There is nothing new to report on the cub's cuteness. Just had to use the "C" word again.

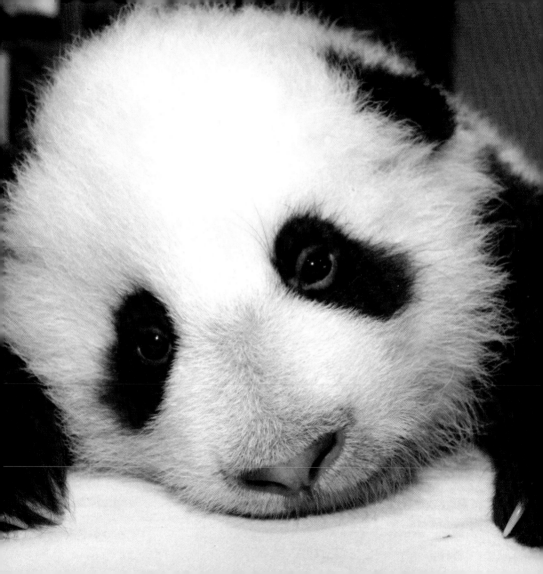

The cub took a step yesterday! He lifted himself up and was swaying on all four legs when he suddenly took a step forward and fell on his face. After all the effort, he immediately fell asleep.

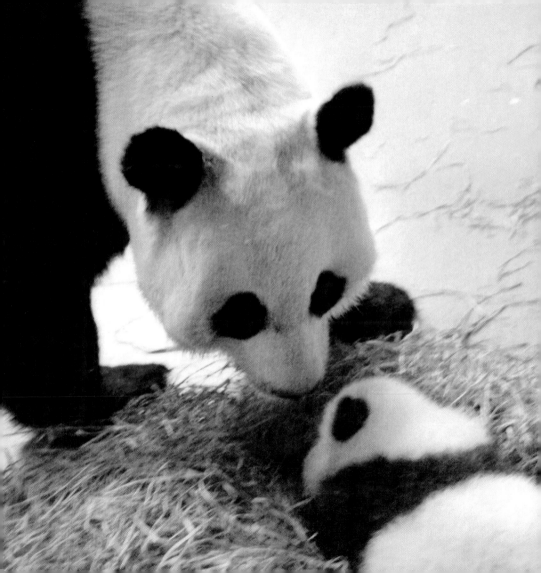

The cub spent this morning trying to crawl and walk. After he tried for several minutes, he became very vocal and squealed loudly. It really seemed as though he had gotten tired and cranky from all the effort. All this put Mei Xiang in a very anxious mood. She restlessly wandered through the exhibits and returned frequently to check on the active cub. When she went back outdoors, she gave us a wheezy huff, letting us know she was indeed quite perturbed by this development.

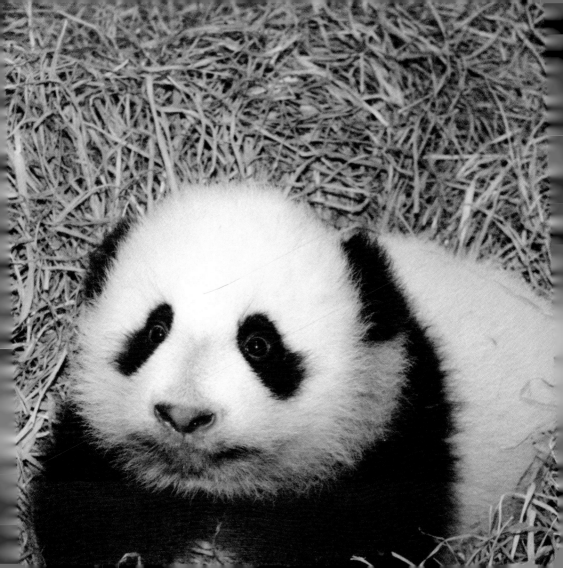

The cub stood up and turned around a few times this morning. There has not been a repeat of his quadrupedal feat, but now we know this secret, since Mei Xiang was absent during his walkabout. We all wonder how she is going to react when he takes off right in front of her.

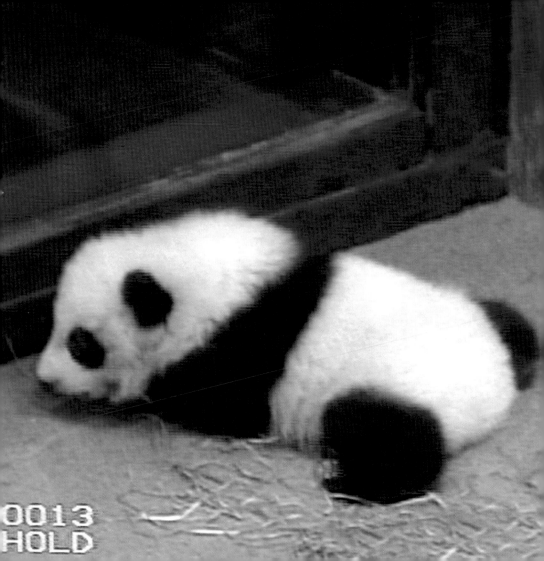

0013
HOLD

Tai Shan spent this most auspicious hundredth-day celebration of his life and the proclamation of his name asleep in the den. Tai Shan, our "peaceful mountain," was truly at peace in his remote den.

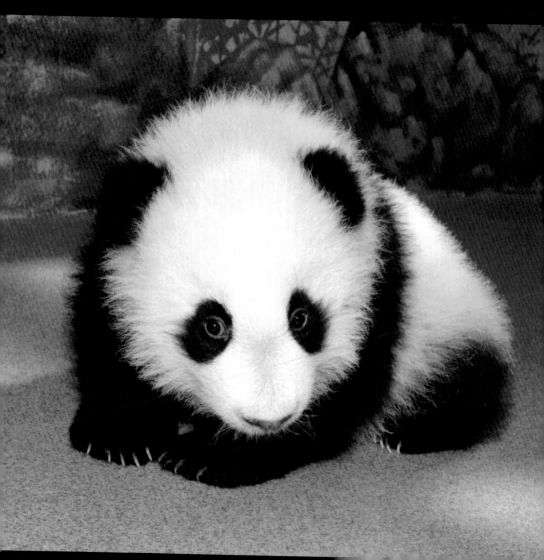

This morning Tai Shan was on the move. He wandered several feet in the exhibit enclosure. What was most remarkable was that, in addition to walking, the little explorer was actually looking around! At last, a new world is unfolding before his eyes!

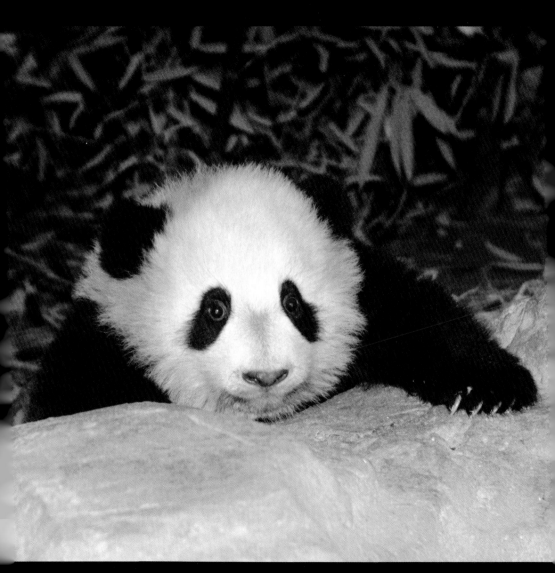

We recently observed Tai trying to climb up on the den platform on which Mei frequently rests. He was not quite up to the task but may be able to climb pretty well by the time he is five months old.

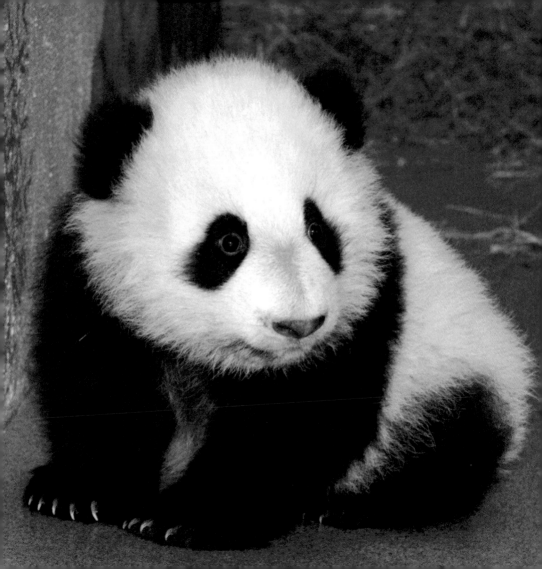

Mei Xiang took Tai Shan on another excursion around the enclosures yesterday. During the excursion, she dragged him up on the rocks, leaving him for brief periods. After moving him back to the floor, Mei also let him follow her. Tai runs to catch up with her and we all cheer him on, as if he were the youngest player in Little League.

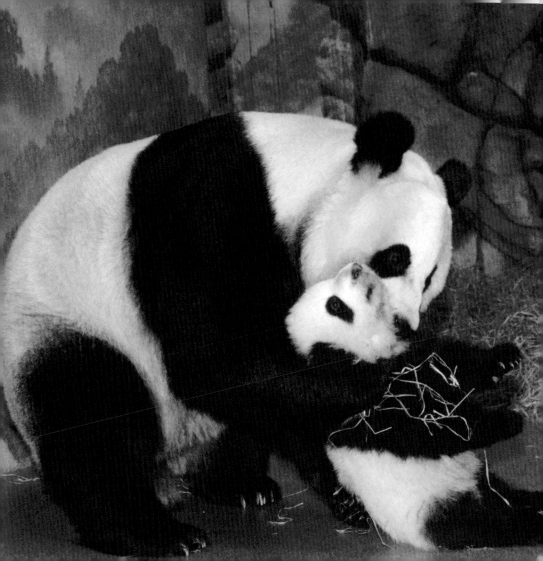

This morning Tai Shan was awake and active for more than an hour! We gave him his own little bunch of bamboo, and he spent a lot of time manipulating and mouthing the stems and leaves. When Mei Xiang came outside, she snacked on his fresh bamboo in perfect panda fashion, while Tai chewed the wrong end most of the time. When he headed up the rocks, Mei decided it was time to return him to the den for a nap.

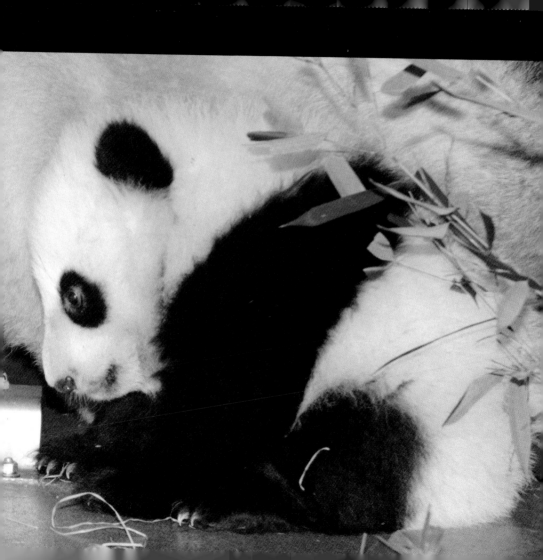

Tai Shan is fascinated by a bracket in the floor just to the left of the den door. He stops to look at it almost every time he walks past it. When he is a little older, we will begin to introduce some toys.

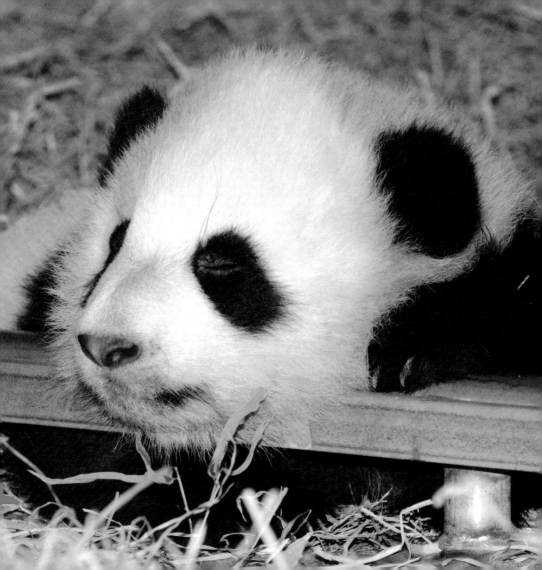

How the world has changed for Tai Shan!

Each morning, after Mei Xiang goes outside to eat, it is playtime for Tai. He comes out of the den as soon as she leaves, ready for a day of exploration. He explores the exhibit before settling in for his all-important naps.

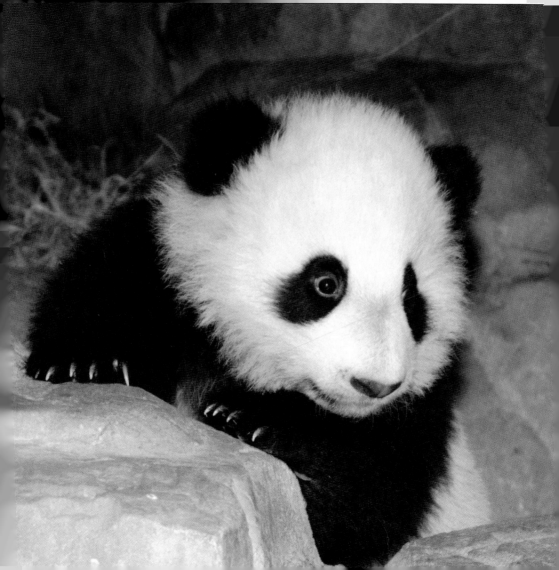

Tai Shan made his big media debut this morning. He was in high gear for about two hours, during visits by members of more than fifty media outlets and more than a hundred reporters from as far away as China, Japan, and Russia. He showed off his new climbing skills and defied gravity over and over again as he walked along the edges of the rocks in his indoor exhibit.

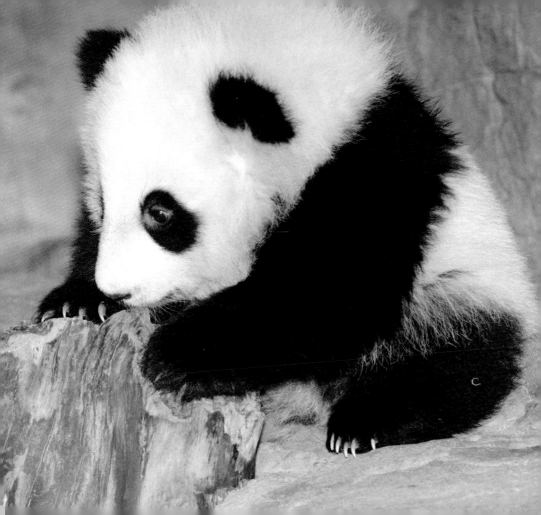

Tai Shan was a climbing fiend yesterday and this morning. He ventured up on the rocks and spent more than half an hour exploring and chewing on an old stump.

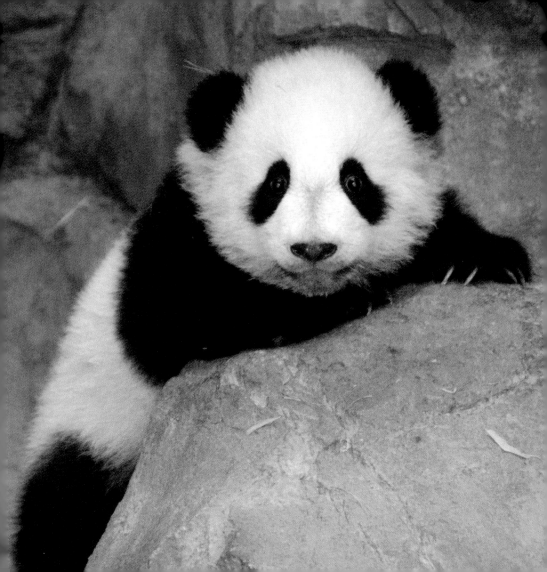

This morning Tai ran after the keepers as they were working. He climbed up on one of their legs and nipped at their pant legs. Here comes trouble! As Tai gets larger and more interested in us, we will have to be careful of his teeth and claws and change the way we work with him. He was very active and ultimately crash-landed into a sound sleep in the empty pool.

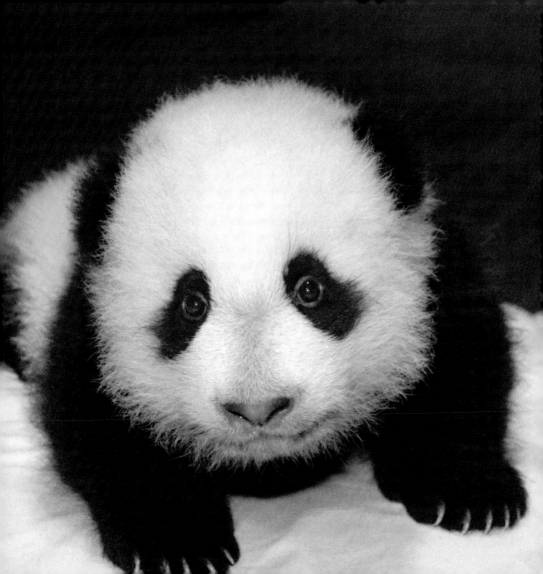

Tai Shan has noticed his reflection in the window. He quietly looks at himself and approaches the glass. When he is near the glass he does not notice the excitement he causes on the other side. His photographing visitors have been dubbed the "pandarazzi." The camera flashes do not bother him, and we have no evidence that they cause any eye problems with either human or panda superstars.

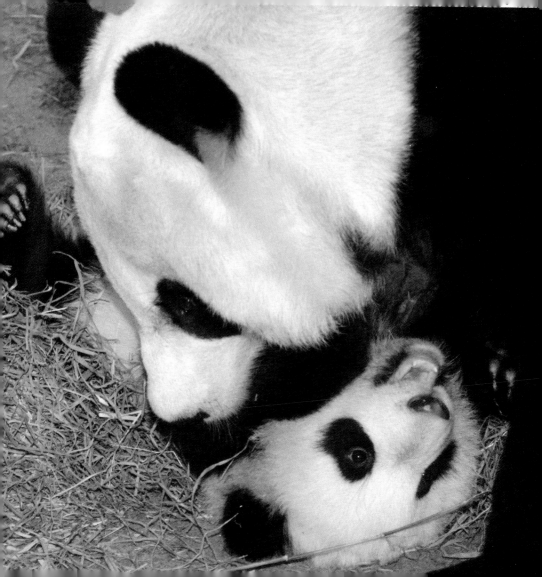

It is so touching to see Mei Xiang interacting with Tai. It's as though the hard work is over and she is beginning to have fun with him. She rolls him under her chin and over her chest, to nibble on him as if he were an ear of corn. She bites and licks him from end to end, and then pushes and swats him around on the floor.

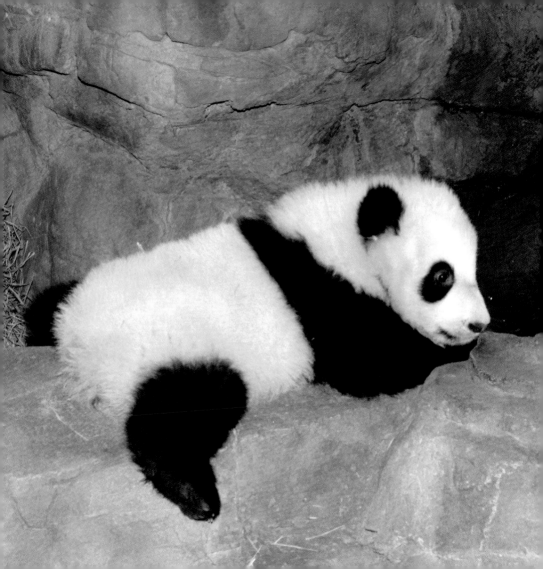

Tai Shan was given the opportunity to go outside this morning but declined and chose to do some rock climbing. In the middle of this walkabout, he seemed to collapse midstep, along a particularly uncomfortable-looking rock ledge, and fell into a sound sleep.

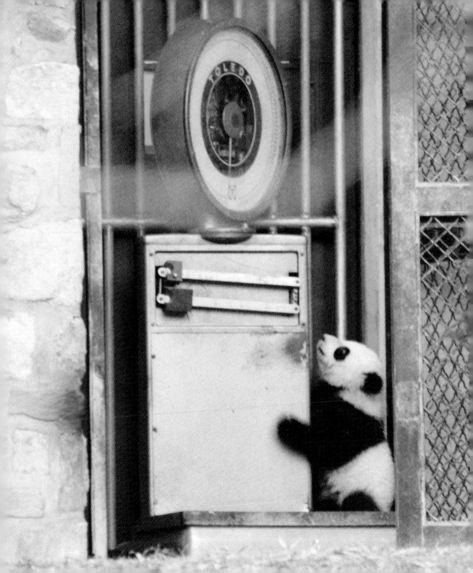

Tai has been enjoying the scale used to weigh the adult pandas. He really likes to climb on and off it, push against it, play on it, and then fall asleep on its platform.

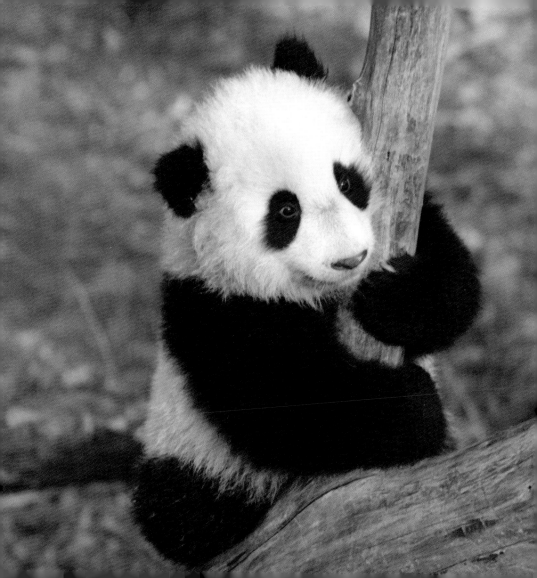

Tai Shan made his first trip outside this morning. He especially enjoyed the dead limbs and spent a lot of time hanging on to them as Mei tried to tug him off. He won just about all of these tugging bouts.

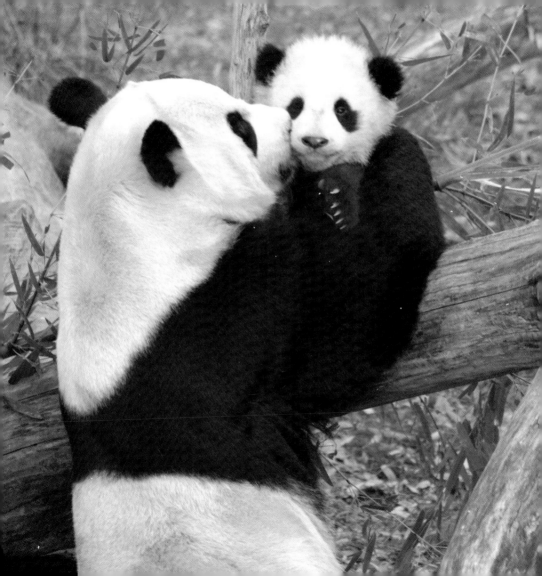

All we can say is that Tai Shan is simply a wild child. We watch him practice his climbing skills on Mei Xiang's back: he grabs a mouthful of her hair along with the skin and pulls and chews relentlessly.

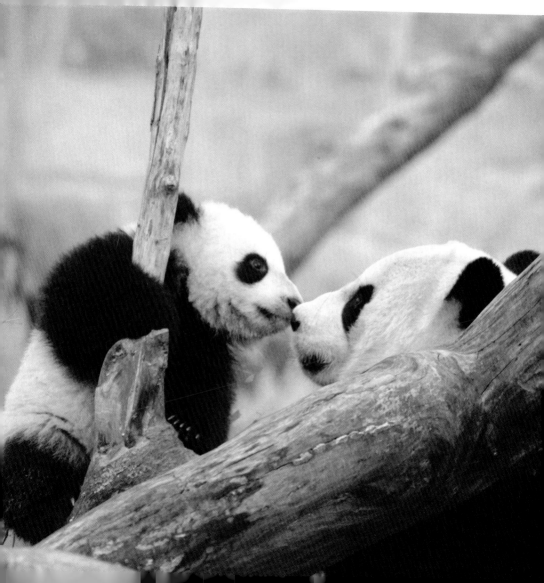

Each morning, Mei and Tai eventually end up playing together by a fallen log at the front of the yard. This is a new destination for Mei, who is drawn there by Tai's antics. Tai leaped from the log onto Mei's back to chew on the ruff of her neck before sliding off and bounding onto the log again.

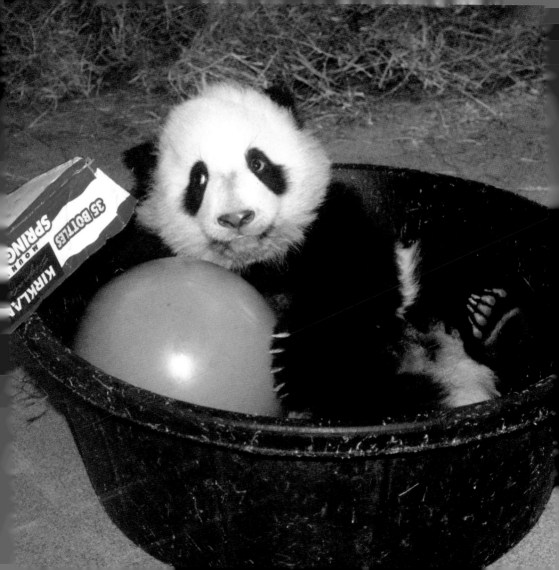

Yesterday, Tai Shan was given a pile of leaves, a cardboard box, and a Kong toy to play with. He interacted with everything. The cardboard box became scary when it turned over on top of him. Tai had to scamper back to the den to regain his composure.

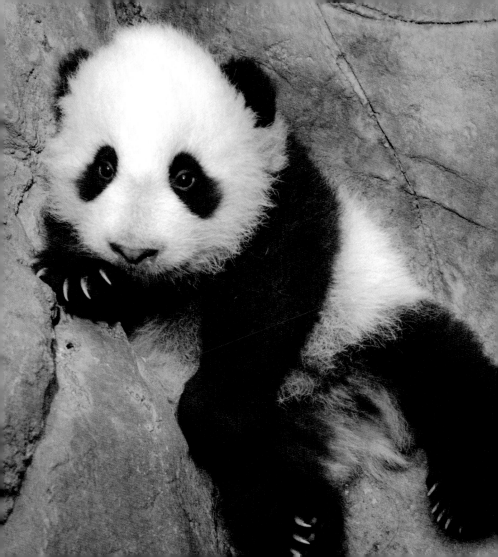

One of Tai's favorite activities is trying to sit up against the rocks, which he can accomplish for a few seconds before tumbling over.

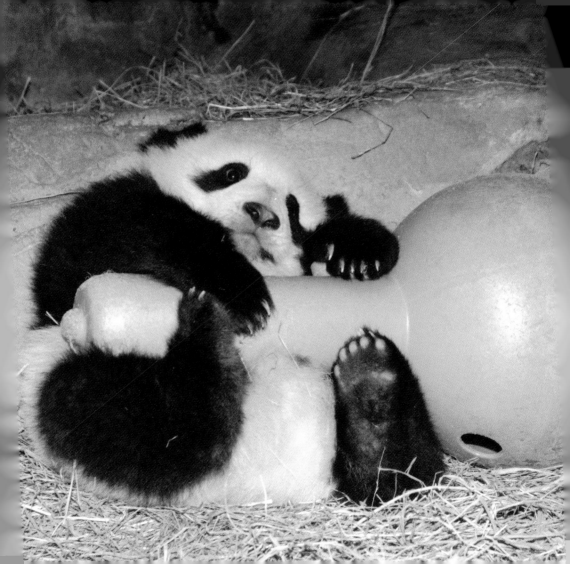

The cute meter went completely off the scale yesterday—twice! Tai Shan was given a hard plastic squash toy, which he played with by grasping it between his legs and biting it. At one point, he fell off it onto his back, and the toy shot out away from him. He then bounced himself back into the den! He looked like a big puff of popcorn as he hopped through the door.

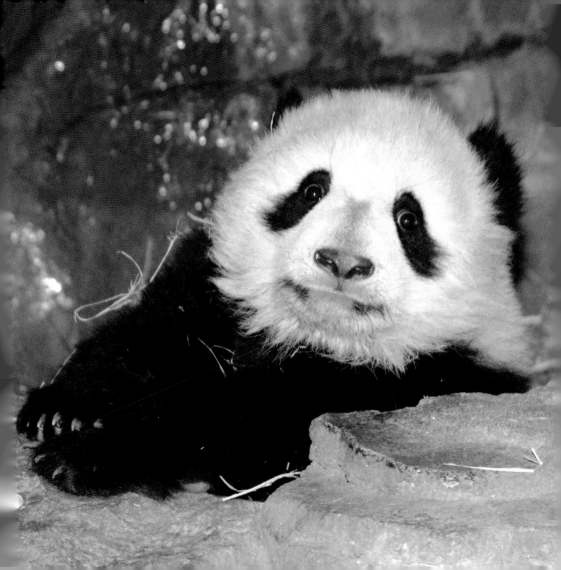

We have a tough time leaving Tai without him trying to follow us. He will track us down, trying to hold on to and bite at our legs. In order to get out of the enclosure, we have to distract him. We have tried using a box, leaves, a ball, and bamboo. These things do not distract him for very long. Sometimes we exit over the rocks to slow him down, because he can catch up to us on the floor.

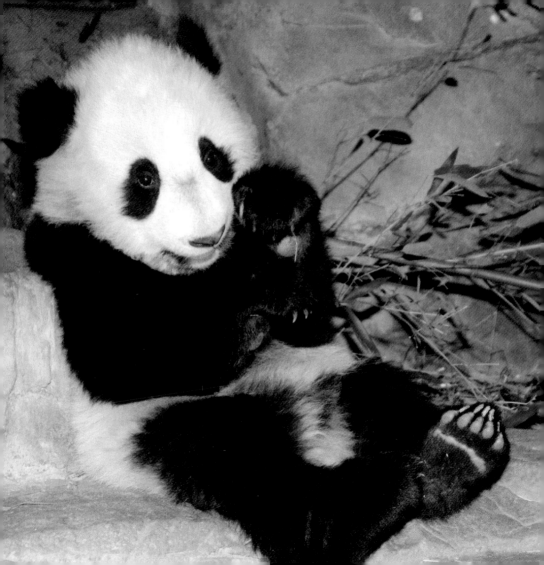

When we measured Tai recently, his abdomen showed the most significant increase of all: 5.46 inches! He has quite a bit more growing to do before he's as big as his 275-pound father, Tian Tian. And he will be just as cute as he is now.

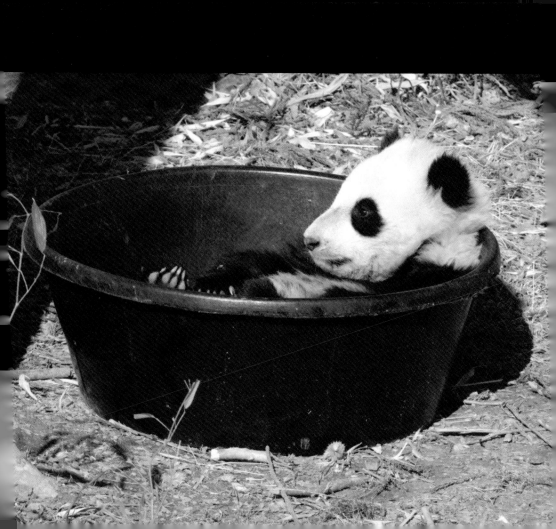

Tai Shan's new favorite place is the black feed tub. It is a great place to play and also a great place for a long nap. It provides him with a sense of comfort and security within the larger space of the exhibit enclosure.

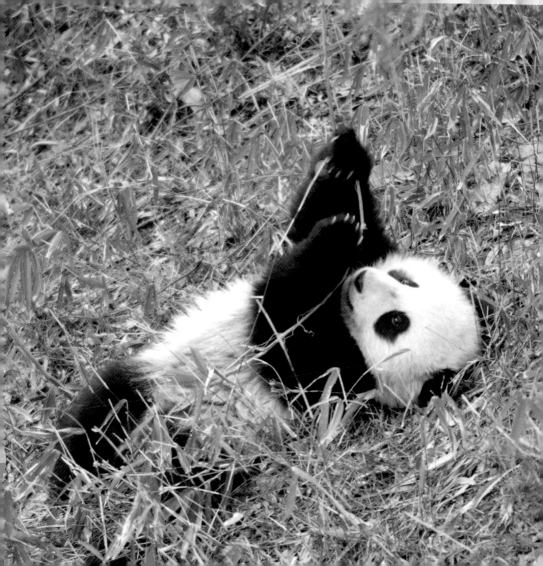

Tai played with a leaf-eater biscuit that Mei Xiang had missed, a very unusual occurrence for Mei. He began to chew on it and ended up consuming the entire biscuit! We still cannot confirm that he is eating bamboo. He chews and chews on the leaves like gum and then spits them out. Like all youngsters, he is enjoying mouthing and chewing on lots of things, like bark, sticks, and the vegetation in the outdoor yards.

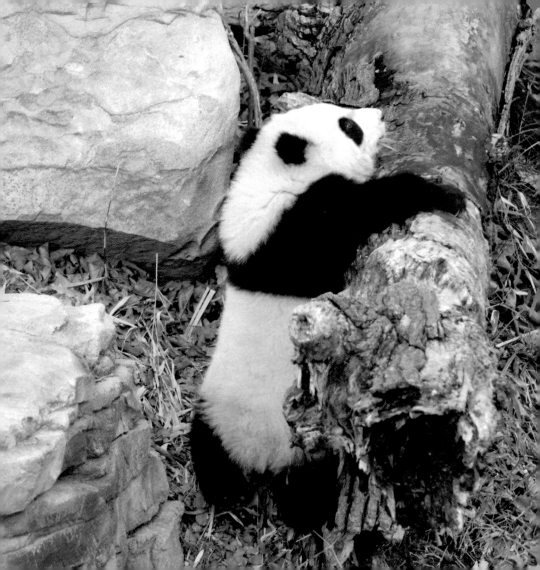

Since Tai Shan climbed his first tree, he has been trying hard to climb another. He does chin-ups, pulling himself off the ground, but then is unable to balance and hoist himself up into the tree. But just like his mother, when he encounters a problem, he is determined to solve it.

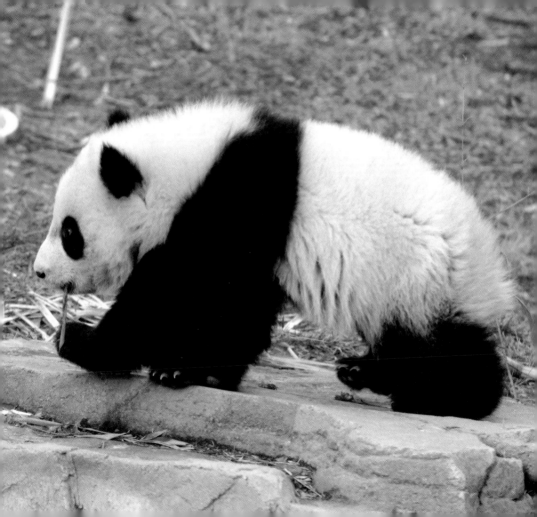

Now seven months old, Tai Shan weighs thirty-three pounds. His cuteness has taken on a longer and lankier profile.

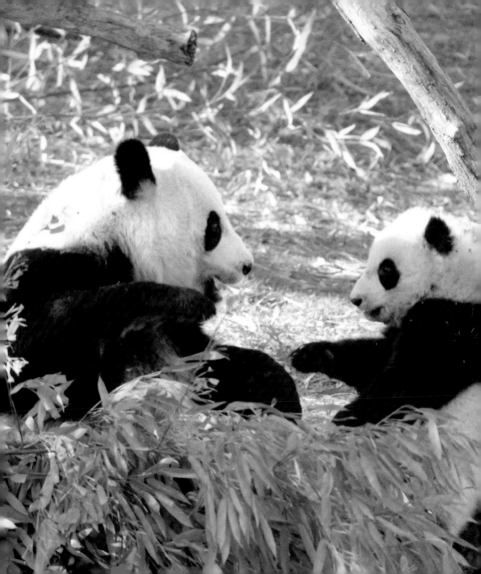

Today Tai followed Mei Xiang through the yard and faced her like a small mirror image of his mother. Mei and Mini Mei!

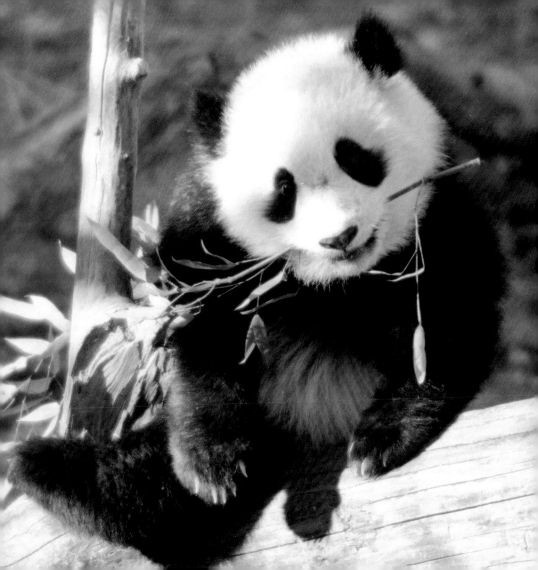

We continue to watch Tai maneuver bamboo like a little adult. He chews and chews on the leaves, and just when we think he might have swallowed them, out comes a shiny, wet, and very intact leaf.

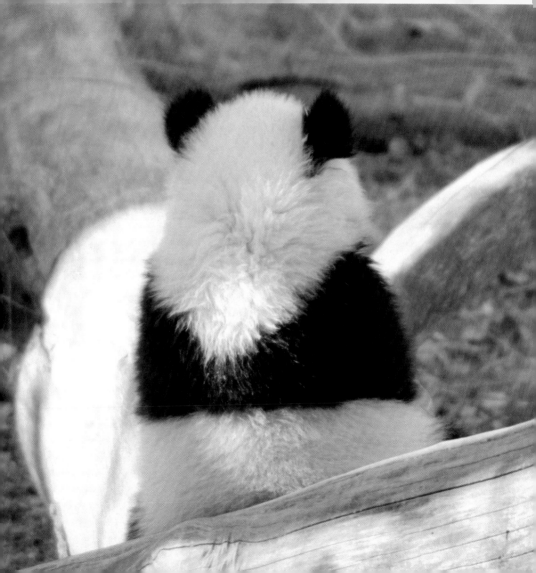

At the Zoo, we get the best view of our panda cub when he's on the ground. Even seen from behind as he gazes into the distance, he is great fun to look at.

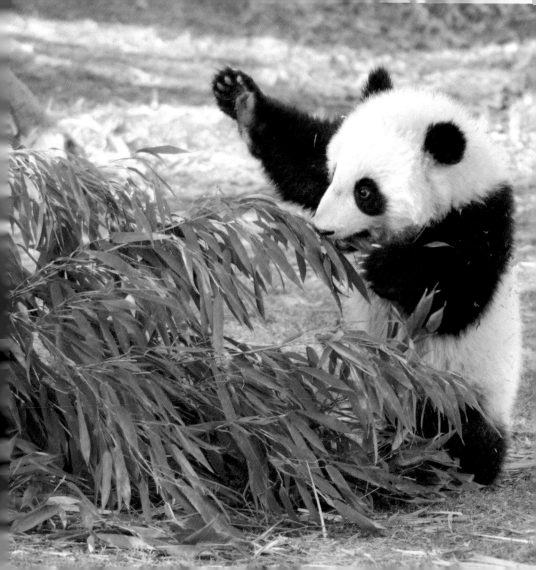

When Tai is awake, if he is not chewing or climbing on Mei to get her to play, he is trying to "help" the keepers move bamboo.

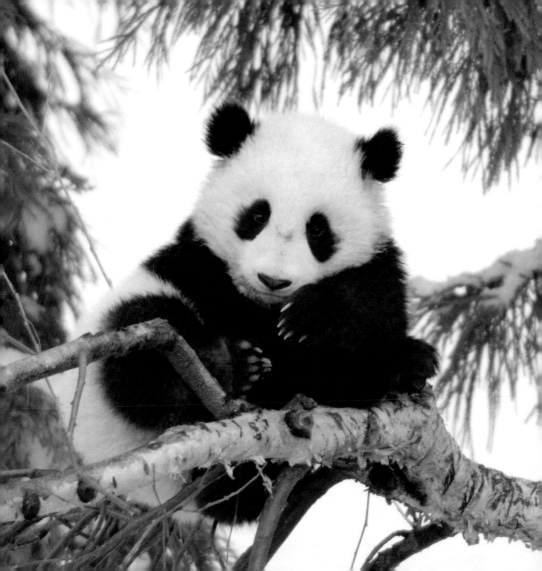

Yesterday morning, having explored every inch of the ground, Tai climbed up a tree. He played up there for hours and climbed as high as eighteen feet. As it grew dark, the keepers wanted Tai to be safe inside for the night. While one person distracted him, another climbed up a ladder and carried him down.

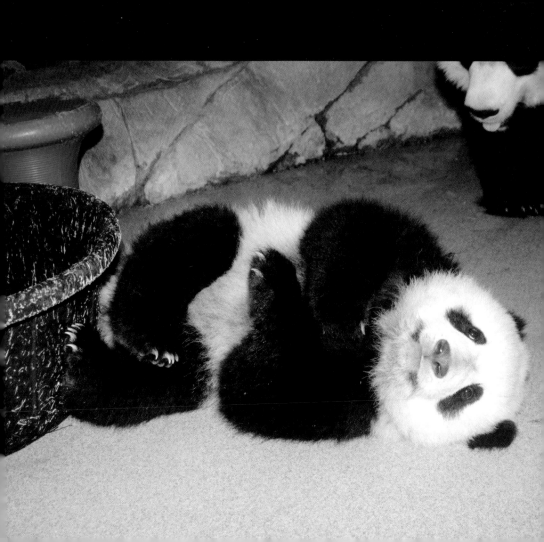

Tai Shan experiences the joy of playing in a rubber feed tub. We sometimes put another toy such as a burlap bag or a Kong toy in the tub to further engage him. He spends a lot of time rolling and tumbling upside down, in and out of the tub.

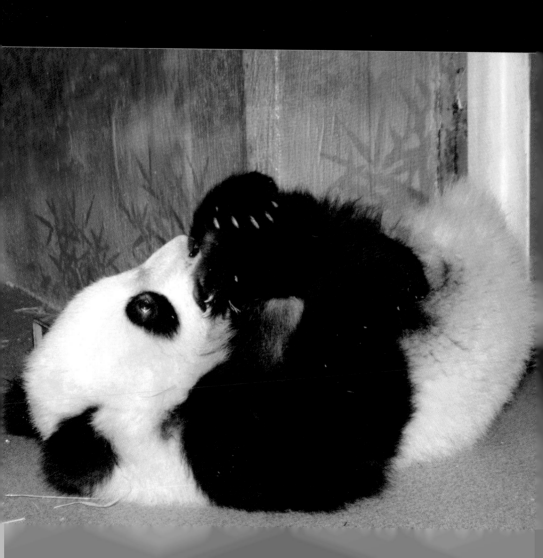

Tai Shan regularly engages in solitary play while resting in the den. He displays the flexibility of pandas by chewing on his hind feet while lying on his back. Too cute!

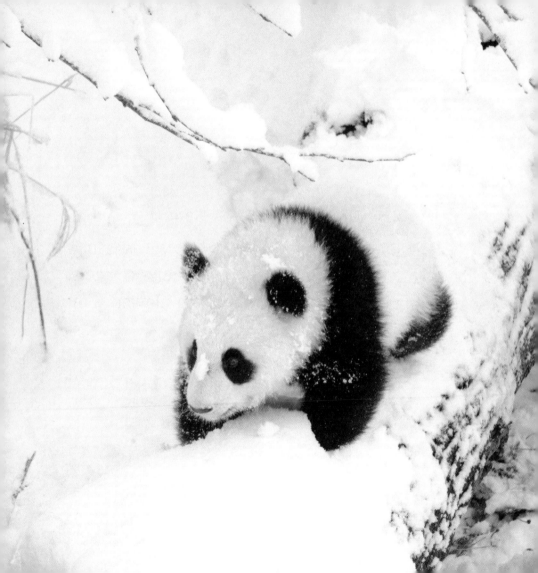

After snow fell throughout the night, the yard became a brand-new world in the morning! Tai Shan experienced his first significant snow. After a brief taste of the powder, he plowed right out into his wonderland.

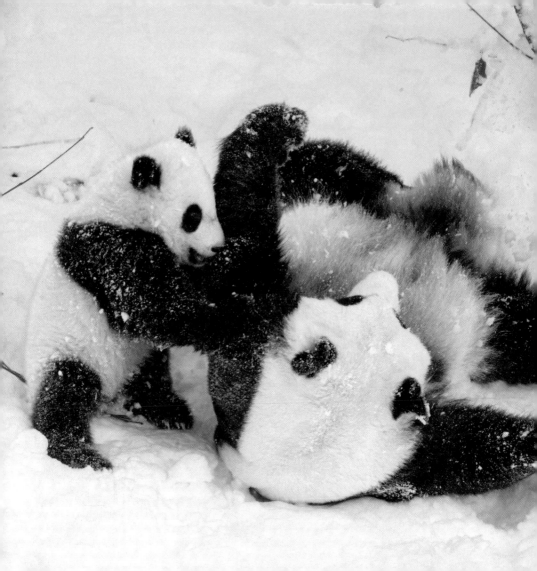

Later, Mei Xiang and Tai had a good play session involving lots of rolling and sliding. With their thick, snow-frosted fur, pandas neaten up again after a good shake. Pandas both young and old really love the snow. Even the most sedate panda will lose it completely over a little snow.

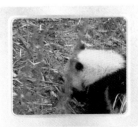

Acknowledgments

Friends of the National Zoo (FONZ) would like to thank Lisa Stevens, the National Zoo's Assistant Curator for Pandas and Primates, for writing the website diary excerpted here; Jessie Cohen, Ann Batdorf, and J'nie Woosley, in the Zoo's Department of Exhibits and Outreach, for taking and managing the photographs; and FONZ volunteers for operating the panda cams. FONZ is also grateful to Fujifilm, the Zoo's lead corporate sponsor, for its generous support of the Zoo's giant panda conservation program, and Animal Planet, lead media sponsor, for its generous support and for co-hosting the Zoo's panda cams.

If you would like to make a donation to FONZ's Giant Panda Conservation Fund or learn more about giant pandas, please go to www.fonz.org.